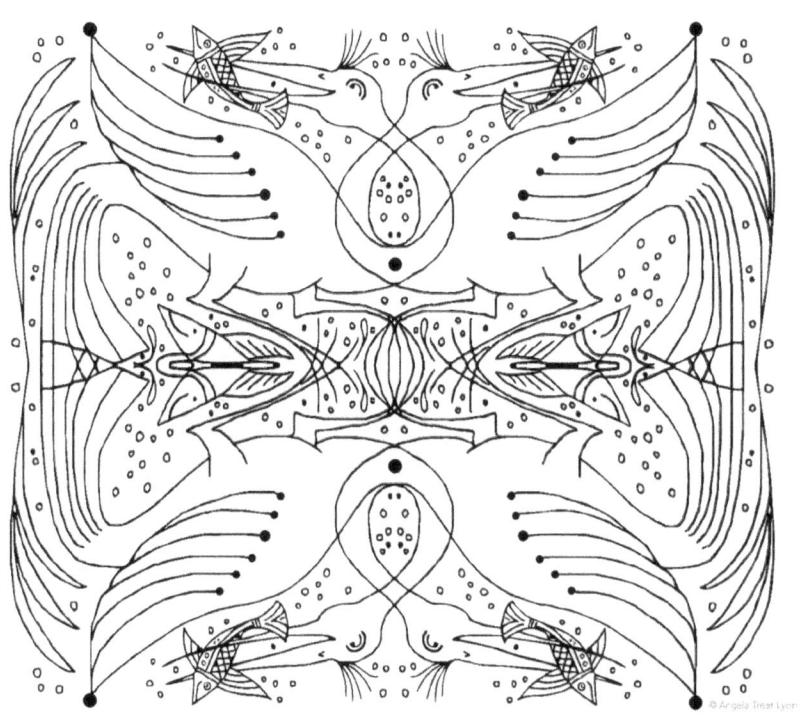

Is Your Critical Info Safe?

Keep Your Emergency Contacts & Important Personal & Business Details Safe

This handy book helps you keep your important information at hand so you can get to it in a flash.

In this day of the easy electronic app it might sound strange to use a printed book, but you'd be smart not have all your critical info on any electronic device that can be destroyed, lost or hacked. Rather than swiping, you get to turn real pages. Make sure to keep these records in a safe and secure place.

46 pages, 8.5" x 11" with soft, durable suede-like cover

What do you get?

* Emergency and household contacts
* School & Medical Information for yourself & kids
* Birthdays & Anniversaries
* Important websites, usernames & passwords
* Personal and business savings trackers
* Galleries where you show

Take care of the details and they'll take care of you

If you have the contacts, phone numbers, record sheets, and all the other details mentioned here, you can see the core of your records all at once.

If you lost your smart phone, what would you do? If there was a fire, what would you do? Grab this book, is what!

What are you waiting for?
Grab this book and start using it right now, so you have all your important data right at your fingertips.

The Info Safe for Artists
Keep Your Emergency Contacts & Important Personal & Business Details Safe

46 pages 8.5" x 11" with soft, cleanable suede-like cover.

© 2019 Angela Treat Lyon
All rights reserved internationally

ISBN: 9781097248599

Cover and inside image: *Droplets Reflection Mandala* © Angela Treat Lyon
Production, cover and interior design by Angela Treat Lyon
AngelaTreatLyonBOOKS.com, MoreOddBooks.com
and EFTBooks.com

Published by
OUT FRONT PRODUCTIONS
Chico, California, USA

The Info Safe for Artists

Keep Your Emergency Contacts & Important Personal & Business Details Safe

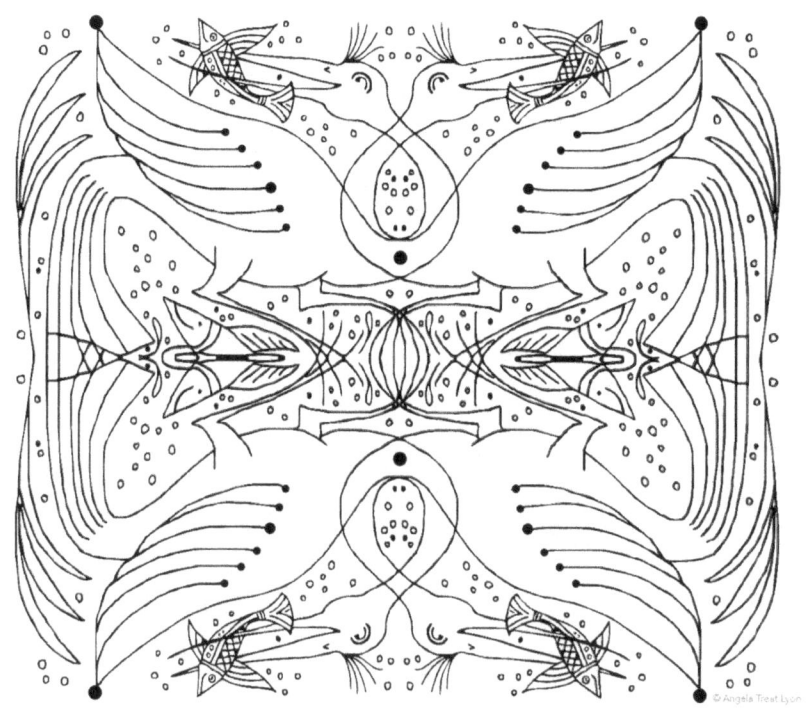

Angela Treat Lyon

Critical Contacts

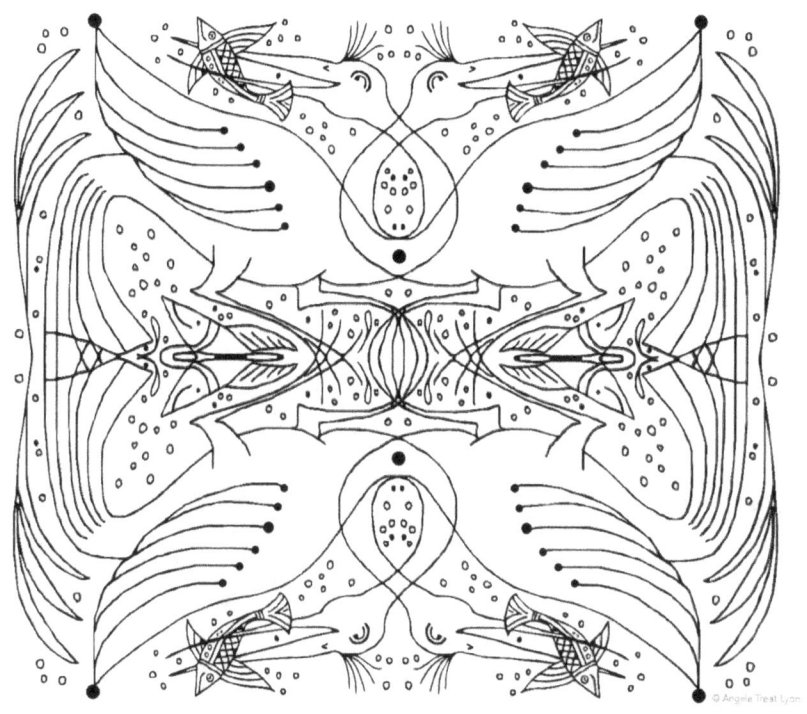

The Info Safe for Artists

Important Contacts

Name, Address, Phone, Email Name, Address, Phone, Email

The Info Safe for Artists

The Info Safe for Artists

Important Websites & Passwords

URL Username Password	URL Username Password
URL Username Password	URL Username Password
URL Username Password	URL Username Password
URL Username Password	URL Username Password
URL Username Password	URL Username Password
URL Username Password	URL Username Password
URL Username Password	URL Username Password

The Info Safe for Artists

The Info Safe for Artists

The Info Safe for Artists

Emergency Contacts

POLICE DEPARTMENT

FIRE DEPARTMENT

AMBULANCE

POISON CONTROL

MOM'S CELL PHONE

DAD'S CELLPHONE

KID'S SCHOOL

FAMILY DOCTOR

SPECIAL CARE DOC

DENTIST

NEIGHBORS

RELATIVES

VET

NOTIFY IF I DIE:

The Info Safe for Artists

The Info Safe for Artists

Household Contacts

Cleaning Services	Repair Man
Contractors	Snow Removal
Landscaping Services	Garbage Pickup
Babysitters	Recycling
Grocery Store Delivery	Pharmacy

The Info Safe for Artists

The Info Safe for Artists

Important Contacts

Name, Address, Phone, Email Name, Address, Phone, Email

The Info Safe for Artists

The Info Safe for Artists

Important Websites & Passwords

URL Username Password	URL Username Password
URL Username Password	URL Username Password
URL Username Password	URL Username Password
URL Username Password	URL Username Password
URL Username Password	URL Username Password
URL Username Password	URL Username Password
URL Username Password	URL Username Password

The Info Safe for Artists

The Info Safe for Artists

The Info Safe for Artists

Family Birthdays & Anniversaries

JANUARY

FEBRUARY

MARCH

APRIL

MAY

JUNE

JULY

AUGUST

SEPTEMBER

OCTOBER

NOVEMBER

DECEMBER

The Info Safe for Artists

The Info Safe for Artists

School Information

Child:
SCHOOL:
SCHOOL PHONE:
PRINCIPAL:
PRINCIPAL PH:
BUS DRIVER:
TIME OF PICKUP:
TIME OF DROP OFF:
TEACHER:
CLASSROOM:
ROOM NUMBER:
INFIRMARY PH:
COACH PH:

Child:
SCHOOL:
SCHOOL PHONE:
PRINCIPAL:
PRINCIPAL PH:
BUS DRIVER:
TIME OF PICKUP:
TIME OF DROP OFF:
TEACHER:
CLASSROOM:
ROOM NUMBER:
INFIRMARY PH:
COACH PH:

Child:
SCHOOL:
SCHOOL PHONE:
PRINCIPAL:
PRINCIPAL PH:
BUS DRIVER:
TIME OF PICKUP:
TIME OF DROP OFF:
TEACHER:
CLASSROOM:
ROOM NUMBER:
INFIRMARY PH:
COACH PH:

Child:
SCHOOL:
SCHOOL PHONE:
PRINCIPAL:
PRINCIPAL PH:
BUS DRIVER:
TIME OF PICKUP:
TIME OF DROP OFF:
TEACHER:
CLASSROOM:
ROOM NUMBER:
INFIRMARY PH:
COACH PH:

The Info Safe for Artists

The Info Safe for Artists

Medical Information

Pediatrician	Family Doctor
Eye Doctor	Family Dentist
Orthodontist	Insurance Information

Name:
Doctor:
Allergies:

Blood Type:

Name:
Doctor:
Allergies:

Blood Type:

Name:
Doctor:
Allergies:

Blood Type:

Name:
Doctor:
Allergies:

Blood Type:

The Info Safe for Artists

The Savings Tracker

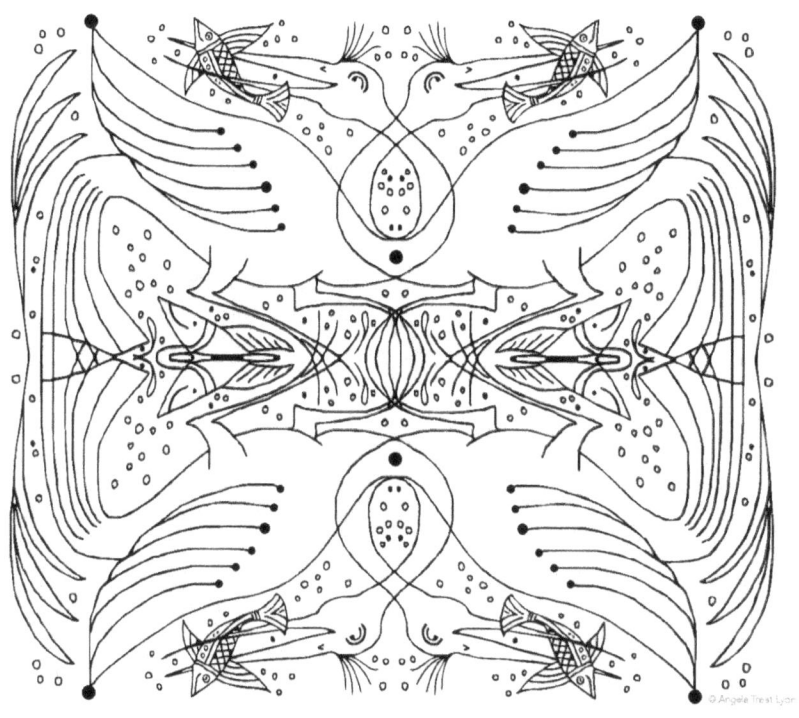

My Savings Tracker

I'm saving for:

Amount needed: _____

Goal date: _____

DEPOSITED	DATE	AMOUNT	NOTES

The Artist's Details Tracker

Business Savings Tracker

I'm saving for:

Amount needed: _____

Our Goal date: _____

DEPOSITED	DATE	AMOUNT	NOTES

Galleries

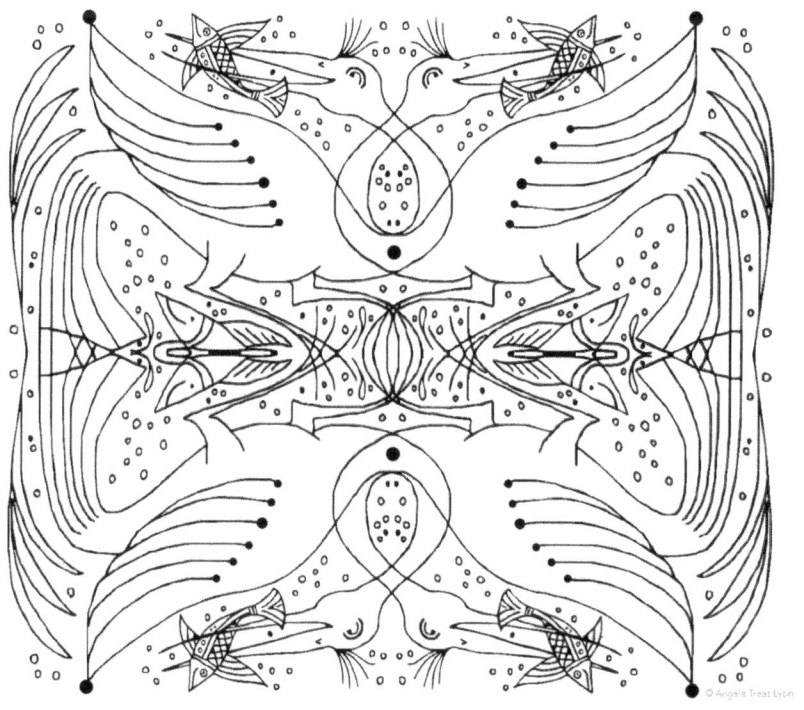

The Info Safe for Artists

Galleries Where I Show

GALLERY
Contact
Email
Phone
Work shown:
TITLE: _____
Type of work: _____
Date in: _____ Date out: _____ My price: _____
TITLE: _____
Type of work: _____
Date in: _____ Date out: _____ My price: _____
TITLE: _____
Type of work: _____
Date in: _____ Date out: _____ My price: _____
TITLE: _____
Type of work: _____
Date in: _____ Date out: _____ My price: _____
TITLE: _____
Type of work: _____
Date in: _____ Date out: _____ My price: _____
TITLE: _____
Type of work: _____
Date in: _____ Date out: _____ My price: _____
TITLE: _____
Type of work: _____
Date in: _____ Date out: _____ My price: _____

Galleries Where I Show

GALLERY
Contact
Email
Phone
Work shown:
TITLE: _____
Type of work: _____
Date in: _____ Date out: _____ My price: _____
TITLE: _____
Type of work: _____
Date in: _____ Date out: _____ My price: _____
TITLE: _____
Type of work: _____
Date in: _____ Date out: _____ My price: _____
TITLE: _____
Type of work: _____
Date in: _____ Date out: _____ My price: _____
TITLE: _____
Type of work: _____
Date in: _____ Date out: _____ My price: _____
TITLE: _____
Type of work: _____
Date in: _____ Date out: _____ My price: _____
TITLE: _____
Type of work: _____
Date in: _____ Date out: _____ My price: _____

The Info Safe for Artists

Galleries Where I Show

GALLERY
Contact
Email
Phone
Work shown:
TITLE: _____
Type of work: _____
Date in: _____ Date out: _____ My price: _____
TITLE: _____
Type of work: _____
Date in: _____ Date out: _____ My price: _____
TITLE: _____
Type of work: _____
Date in: _____ Date out: _____ My price: _____
TITLE: _____
Type of work: _____
Date in: _____ Date out: _____ My price: _____
TITLE: _____
Type of work: _____
Date in: _____ Date out: _____ My price: _____
TITLE: _____
Type of work: _____
Date in: _____ Date out: _____ My price: _____
TITLE: _____
Type of work: _____
Date in: _____ Date out: _____ My price: _____

Galleries Where I Show

GALLERY
Contact
Email
Phone
Work shown:
TITLE: _____
Type of work: _____
Date in: _____ Date out: _____ My price: _____
TITLE: _____
Type of work: _____
Date in: _____ Date out: _____ My price: _____
TITLE: _____
Type of work: _____
Date in: _____ Date out: _____ My price: _____
TITLE: _____
Type of work: _____
Date in: _____ Date out: _____ My price: _____
TITLE: _____
Type of work: _____
Date in: _____ Date out: _____ My price: _____
TITLE: _____
Type of work: _____
Date in: _____ Date out: _____ My price: _____
TITLE: _____
Type of work: _____
Date in: _____ Date out: _____ My price: _____
TITLE: _____
Type of work: _____
Date in: _____ Date out: _____ My price: _____

About the Author/Artist

Angela Treat Lyon is an award-winning, internationally recognized painter and stone carver, author & Business Success Coach who lived and was inspired by her home in Hawaii for over 50 years. She presently lives in Northern California.

Angela has extensive training in multiple alternative/energy healing methods, with thirt plus years of experience using EFT and her extensive skills and intuition to help small business owners, artists and entrepreneurs conquer their fears and doubts so they can move on and reach their goals and achieve their deepest dreams.

At **EFTBooks.com** you will discover how to relieve pain, anxiety and depression using EFT, the Emotional Freedom Techniques. it's not called "emotional freedom" for nothing. EFT books, audios, workshops, courses and groups, and other EFT goodies. Send your friends, family, and clients to **EFTinEveryHome.com**, to get a FREE real-time demo of using EFT (the Emotional Freedom Techniques), as well as other great resources.

Angela's unique original contemporary acrylic and oil paintings, drawings, and prints, and her bronze and stone sculptures are shown in private collections and galleries worldwide. Hundreds of pieces of Angela's unique art: **AngelaTreatLyonART.com**.

Angela is also a highly respected illustrator and graphic designer who designs and publishes books - her own and for others. You can get more of her books at **AngelaTreatLyonBOOKS.com**, **MoreOddBooks.com**, and **Amazon.com**.

www.ingramcontent.com/pod-product-compliance
Lightning Source LLC
Chambersburg PA
CBHW081023170526
45158CB00010B/3135